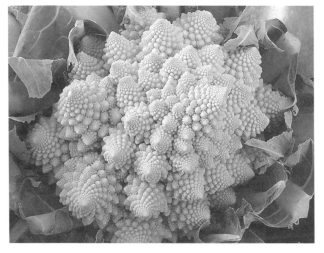

ABOVE: *Romanesco broccoli. This astonishing vegetable has a wonderfully self-similar structure, typical of fractals, with florettes which are smaller versions of the whole.*

US edition © Wooden Books Ltd 2024
Published by Wooden Books LLC,
San Rafael, California

First published in the UK in 2019
by Wooden Books Ltd, Glastonbury, UK

Library of Congress Cataloging-in-Publication Data
Linton, O.
Fractals – On the Edge of Chaos

Library of Congress Cataloging-in-Publication
Data has been applied for

ISBN-10: 1-952178-02-9
ISBN-13: 978-1-952178-02-3

Designed and typeset in Glastonbury, UK

Printed in India on FSC® certified papers by
Quarterfold Printabilities Pvt. Ltd.

FRACTALS

ON THE EDGE OF CHAOS

Oliver Linton

This book is dedicated to Sophie Wilson and Steve Furber, the brilliant designers at Acorn Computers who created the BBC micro and taught us all the joys of programming.

Many of the programs used to generate the images in this book can be found on the author's website: *www.jolinton.co.uk*. To truly understand the nature and simplicity of the algorithms which generate these marvels, there is no better way than to learn how to program a computer. In the 1980s, machines like the Sinclair Spectrum and the legendary BBC micro gave everyone the chance to play the chaos game or write their own one-line Mandelbrot program. These are still available on eBay for modest sums and there is no greater thrill than the sight of your first Mandelbrot set gradually and painfully revealing itself for the first time on your TV screen. Or invest £5.00 in a Raspberry Pi and use a simple programming language such as TinyBASIC or the more sophisticated Python.

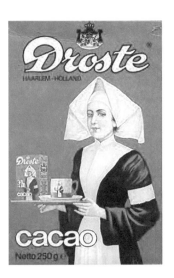

TITLE PAGE, and ABOVE: *The Droste Effect is the technique of placing a picture inside itself to create a recursive image. It gets its name from an image on a Dutch tin of Droste Cocoa which depicts a nun holding a tray with a tin of Droste Cocoa which depicts a nun holding a tray with a tin of Droste Cocoa which depicts a nun holding ...*

CONTENTS

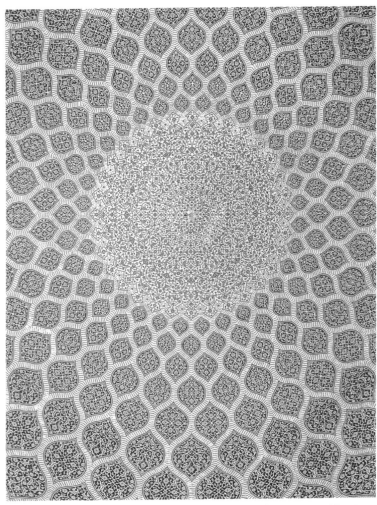

ABOVE: *The interior decoration of the dome of the Sheikh Lotfollah Mosque in Isfahan, Iran uses fractal techniques of repetition and scaling to mirror fractals found in nature.*

INTRODUCTION

Clouds are not spheres, mountains are not cones, coastlines are not circles, and bark is not smooth, nor does lightning travel in a straight line.

Benoit Mandelbrot: The Fractal Geometry of Nature (1982)

FOR 2000 YEARS, mathematicians, scientists and philosophers, blinded by the precision of Euclidean geometry, assumed that everything in the world around us could be built up from spheres, cones, circles, smooth planes and straight lines. They were not entirely wrong: much can be learned by modelling atoms as spheres, faces as multifaceted polyhedra and hurricane winds as straight or circular.

The reason for this is mathematical economy. A sphere is completely described by a single number—its radius; a triangle by three—the lengths of its three sides. Even a hurricane is largely described by just two numbers—its speed of rotation at a characteristic diameter.

But to describe a cloud or a coastline in detail requires millions of numbers. What would be the point? By the time you had written down all those numbers, the cloud would have long since vanished. Coastlines, however, are more permanent and more important too. Have you ever wondered how many numbers are needed to specify the map in your SatNav? The answer is literally billions.

But in 1982, a brilliant Polish born mathematician named Benoit Mandelbrot showed the world that it was possible—sometimes at least—to describe complex structures like clouds and coastlines as easily as spheres and lines, and fractal geometry was born. This book attempts to describe the revolution in mathematics and art which followed.

FRACTALS IN NATURE

and little fleas have lesser fleas

HOW CAN YOU DESCRIBE A TREE? One way is to say that a tree is a stick with two or more smaller trees sticking out of it. This may not be very poetic, but once you have specified how many branches the tree must have and what the angles the branches make with the stem it is sufficiently accurate to enable a computer to draw a quite realistic one (*below left*). Likewise a nautilus shell may be described as a smaller nautilus shell with an extra segment added (*opposite lower left*). In each case the whole is defined in terms of a smaller part of it.

Why are so many structures in Nature fractal? One reason is that fractals often arise spontaneously out of the repeated application of relatively simple rules (*see river delta opposite*). Nature also uses fractals for reasons of economy (*see leaf veins pattern below right*), as fractal structures are often the most efficient way of performing a task, from a tree absorbing sunlight to a lung transferring oxygen to the blood.

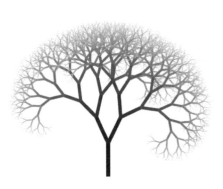

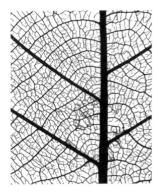

ABOVE: A 100% computer-generated fractal land-scape, typical of many used in modern movies.

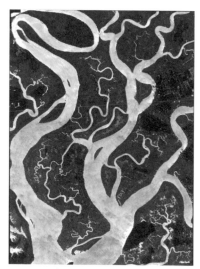

ABOVE: Similar to the structure of trees, the water-ways and tributaries of this river delta form a fractal.

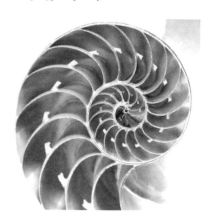

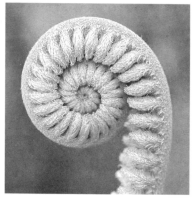

LEFT: Trees and leaves display the self-similarity between parts and whole which are typical of fractals.
ABOVE: Logarithmic spirals are self-similar at any scale, e.g. in Nautilus shell (left) or fern shoot (right).

THE KOCH SNOWFLAKE
the first fractal

The defining characteristic of a fractal is that, however much you magnify it, more and more detail is revealed. With naturally occurring fractals such as cauliflowers and coastlines, the magnified regions are different in detail but most mathematical fractals are self-similar—that is to say, the magnified detail is exactly the same as the whole thing. The first such self-similar fractal was described by a Swedish mathematician called Helge von Koch in 1904 and is very easy to construct.

Take a line (1., *below*); next convert the middle third into a equilateral 'tent' (2.) producing four lines of equal length; repeat the process on all four lines to gives you the second stage (3.); and so on (4.).

When you have repeated this an infinite number of times (!) you have a Koch curve. Put three Koch curves in a triangle and you have a Koch snowflake (*opposite top*). Amazingly, it turns out the length of the perimeter of the snowflake in infinite but the area it encloses is finite.

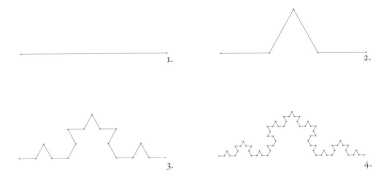

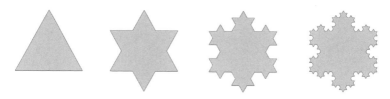

ABOVE: Four stages in the construction of a Koch snowflake. At each stage the length increases by the same amount and so after an infinite number of stages the length is infinite, although the area, is finite (because it easily fits on this page), and exactly 60% larger than the original triangle.

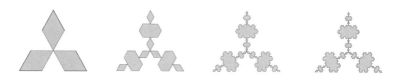

ABOVE: Four stages in the construction of an inverted Koch snowflake, the introspective sibling of the primary Koch snowflake shown above. This is also what is left over when snowflakes are placed side by side. As before the length is infinite but the area is only 40% of the original.

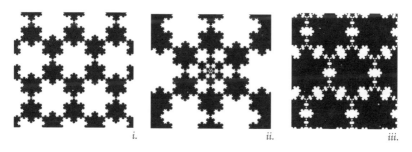

ABOVE: i. Since the Koch snowflake is self similar, amazingly a large snowflake will interlock with one which is √3 times smaller. ii. Alternatively, the whole plane can be covered with an infinite regress of smaller and smaller snowflakes. iii. The final image shows how snowflakes and inverted snowflakes can fit together to tile the plane.

HAUSDORFF DIMENSIONS
how long is a coastline?

We live in a three-dimensional world, while the surface of a table has two dimensions and a line (even a wiggly one) has only one dimension.

One way of counting the number of dimensions of an object is to count how many numbers you need to specify a point on that object. If you tell a friend that your house is 2½ miles down the lane, you imply the road is one-dimensional. Your SatNav needs two numbers, latitude and longitude, so the surface of the Earth is two-dimensional.

But what about the Koch curve? It looks like a line, so it ought to be a one-dimensional object. But our method doesn't work, because the curve is infinitely long and all points on the curve are an infinite distance from the start!

How can we better count dimensions? A cube is three-dimensional because you need 8 unit cubes to double its size—and 8 is 2^3 (2×2×2). To make a 5×5 square you need 25 unit squares—and 25 is 5^2. To make a line 7 units long you need 7 unit lines—and 7 is, of course, 7^1. The pattern is clear; if you need l unit objects to make it m times larger then the number of dimensions the object has is d where $l = m^d$.

The Koch curve is constructed out of 4 unit line segments. If you put together 4 Koch curves you end up with an identical Koch curve which is exactly 3 times larger. Using the letters we introduced earlier, this means that $l = 3$ and $m = 4$, so we are looking for a number d such that $3^d = 4$. This number is 1.262 and is known as the _Hausdorff dimension_ of the Koch curve (_see appendix, page 58_) and since this is greater than 1 and less than 2, the Koch curve is more than a line—but less than a surface!

6

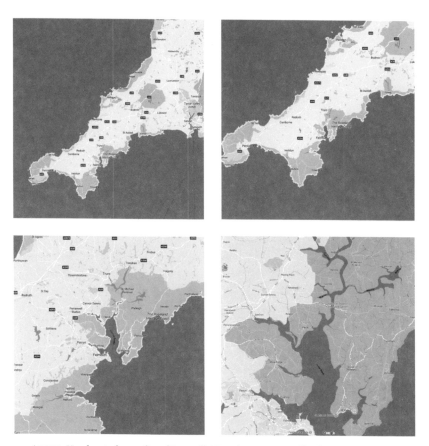

ABOVE: *How long is the coastline of Cornwall, UK? If you arm yourself with a map and a pair of compasses set to a scale distance of 5 miles, you can step your way round the map from Plymouth to Bude in about 35 steps, or 175 miles. But if you set your compasses to a scale of 1 mile, you will find yourself going into many more bays and up many more rivers and you will probably measure the the coastline at about 210 miles; in other words, each of the original 5 mile steps becomes 6 miles. The Hausdorff dimension of Cornwall is therefore about 1.11 ($5^{1.11}$ = 6; as log(6)/log(5)=1.11). Note: the 'official' distance between Plymouth and Bude along the South West Coastal Path may be 290 miles, but this is only true for walkers. For an ant, stepping round every stone, the distance would be much greater.*

L-SYSTEMS
ahead, turn right, then left

The Koch curve (*see page 4*) can be defined using a simple formula: take a step forward (A); turn left 60° (+); step forward (A); turn right 60° (-); turn right another 60° (-); step forward (A); turn left 60° (+); step forward (A). This can be coded into a short string "A + A − − A + A: 60°". To generate each subsequent stage of complexity, we replace "A" in the formula with a copy of the whole formula:

$$A \rightarrow (A + A - - A + A) \rightarrow (A+A--A+A)+(A+A--A+A)--(A+A--A+A)+(A+A--A+A) \rightarrow \dots$$

A formula like this is called an L-system after Hungarian biologist Aristid Lindenmayer who developed the idea in the 1960s. The *Lévy C-curve* (*below*) is given by "+ A − − A +: 45°". More complex L-systems employ more than one formula (*called A, B, C … etc, see opposite*).

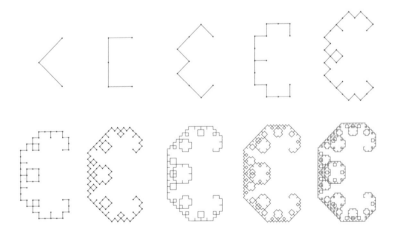

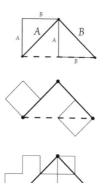

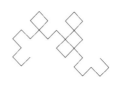

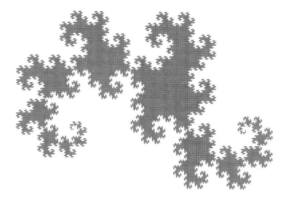

ABOVE: The Dragon curve has interesting properties. If you take a strip of paper, fold it in half and half again, then let it spring open, it will take the shape shown in the first of the diagrams shown on the left. Every time you fold it in half, it will take the form of the next stage down. Since two copies of the curve make one which is $\sqrt{2}$ times larger, its Hausdorff dimension is $\log(2)/\log(\sqrt{2}) = 2$.

Dragon Curve: $A \rightarrow A - B$ $B \rightarrow A + B$ Angle = $90°$

ABOVE: Various L-system bushes, algae and weeds, devised by Paul Bourke. The image second the left requires 21 formulae, while the weed on the far right needs only three. The formulae for these and others are available at http://paulbourke.net/fractals.

SPACE-FILLING CURVES
how dense can you be?

It seems unlikely but it is actually possible to draw a single line which passes through every point in a certain region of the plane. The fractal below (called the *Cesàro curve*) is closely related to the Koch curve in that its 1st stage consists of four lines of equal length but instead of the angle at the apex of the triangle being 60° it is close to zero.

If you make the angle at the apex even smaller and plot more and more stages, eventually the whole triangular space is completely filled.

Shown opposite is the beautiful space-filling *Peano-Gosper curve*, which is made of 7 unit segments and uses two definitions A and B:

$$A \rightarrow A + B + + B - A - - A A - B +$$
$$B \rightarrow - A + B B + + B + A - - A - B \: : \: angle \: 60°$$

The Peano curve is cunningly designed so that the 7 unit segments make a base line which is exactly $\sqrt{7}$ in length (the hypotenuse of the triangle of base $2\frac{1}{2}$ and height $\sqrt{3}/2$ is $\sqrt{7}$). Like the Dragon curve, its Hausdorff Dimension is therefore log (7) / log $(\sqrt{7})$ = 2. All space-filling curves have a Hausdorff Dimension of 2 (but not all curves with HD = 2 are space-filling).

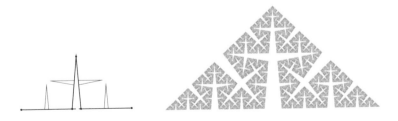

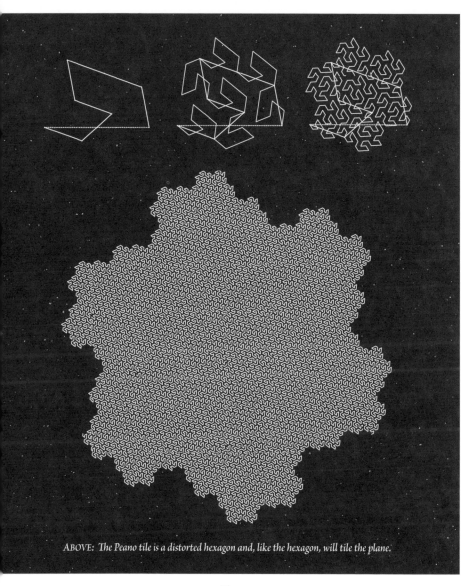

ABOVE: The Peano tile is a distorted hexagon and, like the hexagon, will tile the plane.

CARPETS AND SPONGES
not quite the hole thing

There are many ways of making fractals—here is another one. Start with a filled square. Divide it into nine smaller squares. Rub out the centre square. Do the same with the eight remaining squares again and again. You end up with a carpet full of holes—a *Sierpinski carpet* (*below left*). This has one advantage over a real carpet. If you buy one which is 3 times wider, it will only cost you 8 times as much (instead of 9). Its Hausdorff dimension is therefore $\log 8 / \log 3 = 1.89$.

Other interesting variations are easily generated by rubbing out different squares—the *Vicsek Carpet* (*below right*) is made by repeatedly rubbing out the four corner squares. Since 5 copies make a carpet 3 times wider, its Hausdorff dimension is $\log 5 / \log 3 = 1.46$.

Alternatively, you can start with a different shape, a triangle, hexagon or solid object. The *Sierpinski Triangle*, *Sierpinski Doily* and *Menger Sponge* are shown opposite.

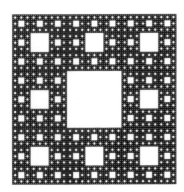 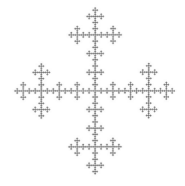

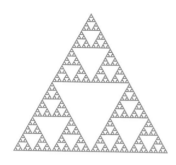
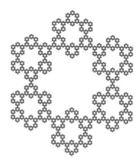

ABOVE LEFT: *The Sierpinski Triangle; 3 copies make a triangle twice as wide so HD = log 3 / log 2 = 1.58.*
ABOVE RIGHT: *The Sierpinski Doily; 6 copies make a doily 3 times wider so HD = log 6 / log 3 = 1.63.*
BELOW: *The Menger Sponge; 20 copies make a cube 3 times wider so HD = log 20 / log 3 = 2.73.*

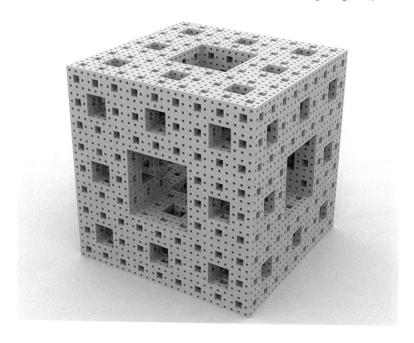

FORD CIRCLES
and Farey addition

Some fascinating fractal patterns can be made with circles. Place two touching circles on a line (*labelled 0/1 and 1/1 below*). Next, put a circle (*labelled 1/2*) in the gap below—this circle has its centre halfway along the line and a radius 1/4 of the radius of the large circles. Now place two more circles (*labelled 1/3 and 2/3*) in the gaps on either side. These circles will have their centres 1/3 and 2/3 along the line and radius 1/9. The next two circles have their centres at the points 1/4 and 3/4 and radius 1/16. In fact, every rational fraction p/q has an associated Ford circle with radius $1/q^2$ which exactly touches the two above it!

But there is an even more remarkable fact about this nest of circles. Look at the fractions in 7ths. In each case the fraction is the sum of the fractions above it—not the algebraic sum, but the *Farey sum* which you get by adding the numerators together and the denominators too—just like you always wanted to. E.g. the Farey sum $1/2 \oplus 2/3 = 3/5$.

We shall meet this fascinating sequence of fractions again when we study the Mandelbrot Map (*see page 50*).

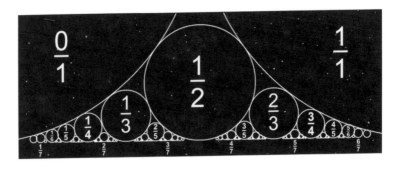

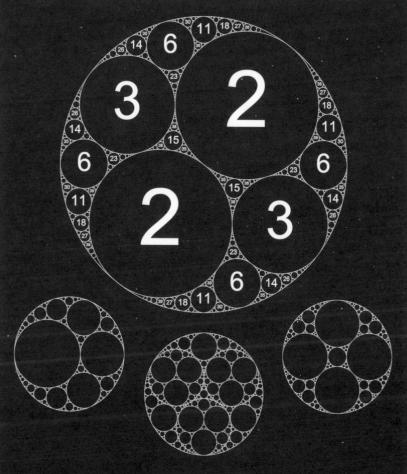

ABOVE: examples of Apollonian gaskets. These are generated by drawing two touching circles inside a larger circle and then filling in the gaps in exactly the same way. The upper gasket is special in that every circle has integer curvature (the curvature of a circle is the reciprocal of its radius). The curvatures a, b, c and d of any four mutually touching circles are related by the formula:

$$a^2 + b^2 + c^2 + d^2 = 2(ab + ac + ad + bc + bd + cd)$$

THE CHAOS GAME
not so random fractals

Here is a completely different way to generate a fractal: set up three fixed poles with flags on them on a large field; call them A, B and C. Start anywhere you like; roll a die – if it comes up 1 or 2 move a little over halfway towards A, if 3 or 4 move towards B and if 5 or 6 move towards C; place a stone on the ground; repeat ad infinitum (or until you get bored). Better still—use a computer. The picture (*below*) is is the sort of thing you get after about ten thousand steps, each of them being 55% towards the next pole:

The amazing thing about this pattern is that it doesn't matter where you start, you are inevitably drawn in to placing the stones in triangular piles—a Sierpinski triangle in fact. This is our first example of an *attractor*, a pattern of points which are locked into a never-ending cycle.

Many interesting fractals result if you play the game with a different number of poles and add certain restrictions like not choosing the same pole twice running or not landing on certain areas (*see examples opposite*).

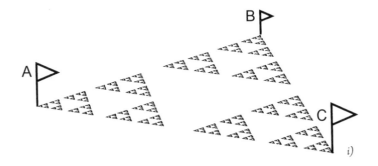

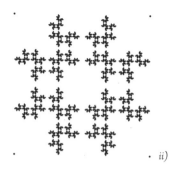

ii)

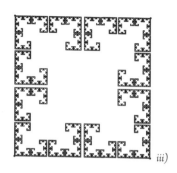

iii)

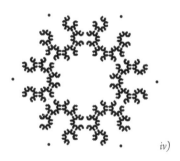

iv)

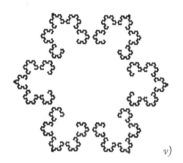

v)

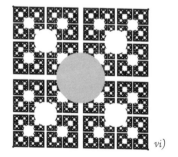

vi)

Examples of Attractors. These fractals were
generated using the following rules:

i) 3 poles; no rules; 55%
ii) 4 poles; new pole not previous pole; 51%
iii) 4 poles; new pole not opposite pole; 51%
iv) 6 poles; new pole not previous pole; 65%
v) 6 poles; new pole not opposite pole; 68%
vi) 4 poles with a forbidden circle (if you land in
the shaded circle then choose another pole); 51%

ITERATED FUNCTIONS
fractals by transformation

The Chaos Game described on the previous pages is a simple example of an Iterated Function System or IFS. In an IFS the way the point moves is defined by two or more mathematical transformations which enable you to calculate where any point (x, y) moves to. In simple systems, these transformations are linear, so the plane is translated (moved), rotated, scaled or sheared. A linear transformation comprises two linear equations, one each for x and y:

$$x \to ax + by + e \qquad y \to cx + dy + f$$

A simple way to illustrate a transformation is to see what happens to a unit square or rectangle. Repeated application of a single transformation moves a point A to B, C, D, E etc (*below*). A Koch curve requires four transformations. Each shrinks the starting rectangle (*below*) to one-

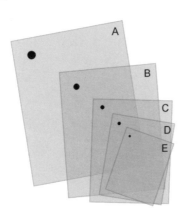

third of its size, with two repositioning it bottom left and right and two of them also rotating the rectangle, 60° to the left and right.

To form an IFS fractal you start with *any* random point (x, y) and then randomly select and apply *any* of the available transformations, and repeat and repeat—eventually the point will be confined to the fractal.

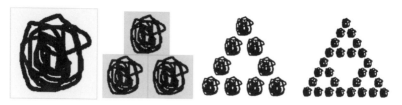

ABOVE: Iterate "shrink and make three copies" to convert any object into a Sierpinski triangle (p. 14).

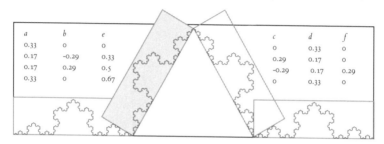

a	b	e		c	d	f
0.33	0	0		0	0.33	0
0.17	-0.29	0.33		0.29	0.17	0
0.17	0.29	0.5		-0.29	0.17	0.29
0.33	0	0.67		0	0.33	0

ABOVE: Four iterated transformations (shrink and reposition four copies) will convert any object into a Koch curve (see page 4).

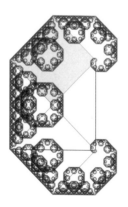

ABOVE: Two transformations make an IFS version of the Levy C-Curve (see page 8).

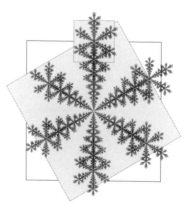

ABOVE: Two transformations make a Snowflake: 1. Rotate left 60°. 2. Shrink and move.

THE BARNSLEY FERN
fractal form and function

In 1988, Michael Barnsley discovered a theorem which says that any shape at all can be described by a set of linear transformations. To discover what these transformations are, you simply make a collage of small copies of the shape which completely covers the large one. The greater the amount of self-similarity in the original shape, as in a maple leaf or a tree, the fewer transformations you will need.

A fern is self-similar in three ways: firstly, the whole leaf minus the bottom two leaflets looks like the whole leaf; secondly, the bottom left leaflet looks like the whole leaf; thirdly, the bottom right leaflet looks like the whole leaf except it bends in a different way. In fact to draw the fern opposite we need to use four transformations: 1. we need to draw a stem; 2. we slightly shrink and tip the frame over to the right; 3. we shrink the frame a lot and rotate to the left; 4. we shrink the frame a lot, flip it over and rotate to the right (*see f1-f4 opposite*). The *Maple Leaf* fractal proceeds in a very similar manner while the *IFS Tree* requires six, more complex, transformations (*both below*).

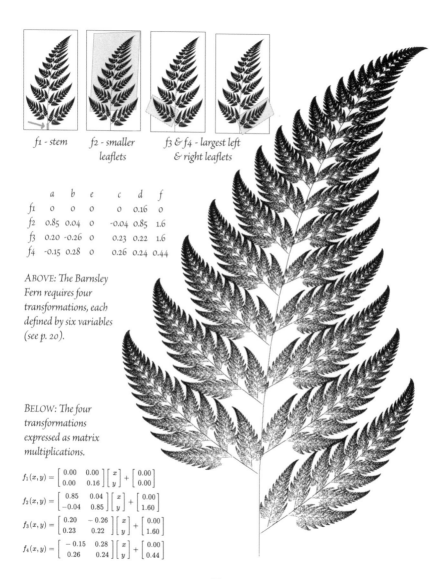

f1 - stem f2 - smaller f3 & f4 - largest left
 leaflets & right leaflets

	a	b	e	c	d	f
f1	0	0	0	0	0.16	0
f2	0.85	0.04	0	-0.04	0.85	1.6
f3	0.20	-0.26	0	0.23	0.22	1.6
f4	-0.15	0.28	0	0.26	0.24	0.44

ABOVE: The Barnsley
Fern requires four
transformations, each
defined by six variables
(see p. 20).

BELOW: The four
transformations
expressed as matrix
multiplications.

$$f_1(x,y) = \begin{bmatrix} 0.00 & 0.00 \\ 0.00 & 0.16 \end{bmatrix} \begin{bmatrix} x \\ y \end{bmatrix} + \begin{bmatrix} 0.00 \\ 0.00 \end{bmatrix}$$

$$f_2(x,y) = \begin{bmatrix} 0.85 & 0.04 \\ -0.04 & 0.85 \end{bmatrix} \begin{bmatrix} x \\ y \end{bmatrix} + \begin{bmatrix} 0.00 \\ 1.60 \end{bmatrix}$$

$$f_3(x,y) = \begin{bmatrix} 0.20 & -0.26 \\ 0.23 & 0.22 \end{bmatrix} \begin{bmatrix} x \\ y \end{bmatrix} + \begin{bmatrix} 0.00 \\ 1.60 \end{bmatrix}$$

$$f_4(x,y) = \begin{bmatrix} -0.15 & 0.28 \\ 0.26 & 0.24 \end{bmatrix} \begin{bmatrix} x \\ y \end{bmatrix} + \begin{bmatrix} 0.00 \\ 0.44 \end{bmatrix}$$

HOPALONG FRACTALS
very strange attractors

So far we have seen what can be done with linear transformations which can translate, rotate, scale and shear the plane. Such transformations are defined by simple linear equations which only contain constants and terms in x and y. If, however, we include terms such as x^2, xy and $\sin x$, then all sorts of weird and wonderful things can happen. One of the first was discovered by the French mathematician Michael Hénon in the 1970s; it involves just one non-linear transformation, but its attractor (*shown below*) is very strange. Provided you start reasonably close to the origin, the point (x, y) quickly homes in on a set of points which looks like a folded line. This, however, is misleading. Firstly the point (x, y) does not follow the line; it 'hops' around apparently at random, only tracing out the complete curve after several thousand iterations. Secondly, if you magnify a section of the line you see that it is not a single line but hundreds of closely spaced lines. It is, in fact, a fractal.

Other formulae can produce surprising results (*see opposite*).

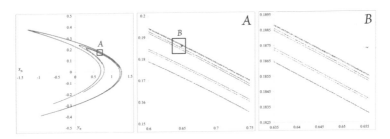

Hénon Attractor: $\quad x \rightarrow 1 + y - 1.4\, x^2 \quad y \rightarrow 0.3\, x$

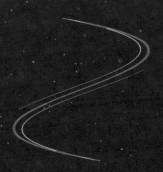

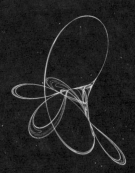

Duffing Attractor:
$$x \rightarrow 2.75x - 0.2\,y - x^3 \qquad y \rightarrow x$$

Tinkerbell: $\quad x \rightarrow (x^2 - y^2) + 0.9\,x - 0.6\,y$
$$y \rightarrow 2\,xy + 2\,x + 0.5\,y$$

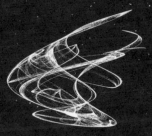

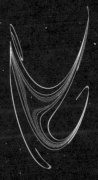

de Jong: $\quad x \rightarrow \sin(2\,y) - \cos(2.5\,x)$
$$y \rightarrow \sin(x) - \cos(y)$$

Linton's Ghost:
$$x \rightarrow \sin(1.2\,y)$$
$$y \rightarrow -x - \cos(2\,y)$$

Classic Barry Martin:
$$x \rightarrow y - sgn(x) \times \sqrt{|(4\,x - 0.5)|}$$
$$y \rightarrow 1 - x$$

THE LOGISTIC MAP
chaos from a simple linear equation

Why is it that one year you don't see a single ladybird and the next there are hundreds? What causes a plague of locusts or a glut of damsons? The answer could lie in a simple idea called deterministic chaos. Take rabbits, for example. With infinite resources, a warren population p can increase exponentially, multiplying by a constant factor k (the 'birth rate') every year. In practice, however, as the population grows, more and more rabbits starve. We can model this by multiplying the population by a second factor (the 'survival rate') for which a suitable expression would be $(1 - p/1000)$. We can therefore predict the behaviour of a population using the simple transformation:

$$p \rightarrow kp\,(1 - p/1000).$$

Suppose the birth rate $k = 2.6$. Starting with $p = 100$ rabbits, after the first year the population will be 234, after the second it will be 466, and it will eventually level out at a steady 615. However, if you increase the birth rate to 3 or more, strange things begin to happen (*opposite top*). First the population begins to oscillate between two values every other year, then it starts to behave chaotically. Note, if you start with a slightly different number of rabbits (e.g. 101) the populations soon diverge.

A simplified version of this is the so-called 'logistic' transformation:

$$x \rightarrow Ax\,(1 - x)$$

Here, if $A < 4$, any value of x between 0 and 1 is transformed into another between 0 and 1, so it can be iterated without limit. Iterating x for each value of A between 0 and 4 results in a line which begins to bifurcate at A = 3, until $A = 3.57$ when chaos sets in up to $A = 4$ (*opposite*).

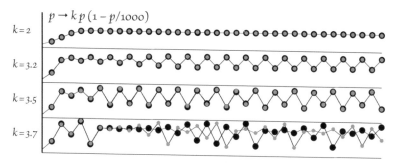

$$p \to k\,p\,(1 - p/1000)$$

$k = 2$

$k = 3.2$

$k = 3.5$

$k = 3.7$

ABOVE: Graphs showing two populations of rabbits as the birth rate k is gradually increased. One population (black blobs) starts with 100 rabbits while the second (grey blobs) starts with 101 rabbits. When k is less than 3 both populations home in on a steady value; as k increases past 3.2 the populations oscillate in an increasingly irregular cycle of boom and bust. However, when k = 3.57 the two populations soon diverge and seem to behave completely randomly.

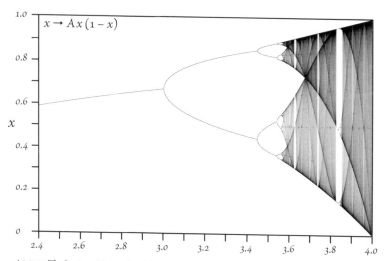

$$x \to A\,x\,(1 - x)$$

ABOVE: The Logistic Map or 'Pitchfork Diagram'. Zooming in to the chaotic region will reveal its self-similar fractal structure with mini pitchfork diagrams and ever smaller 'islands of stability'.

ATTRACTORS AND REPELLORS
seeking stability

Think of a number. Halve it and add 1. Repeat etc. Whatever number you started with, you will close up on 2. Here, 2 is an *attractor*!

Think of a number, double it and subtract 2. Repeat etc. Whatever number you started with (except 2) you end up at plus or minus infinity! Here, 2 is a *repellor*. Why the difference? It's all in the angle.

In the first case (*below*), the slope of the line ($y = \frac{1}{2} x + 1$) is less than 45° and the number progressively homes in on the value of x at P. In the second case, the slope $y = 2x - 2$ it is greater than 45° and the number is repelled away from P. (The 45° line through the origin serves as a means of transferring the output of one calculation into the input of the next.) If the gradient is negative (*as in the two examples below right*) and the slope is shallower than 45°, the number will cycle in towards P, but if it is steeper than 45° it cycles away from it.

Turning to the logistic transformation, $x \rightarrow A x (1 - x)$, the equation $y = A x (1 - x)$ has the form of an inverted parabola (*opposite*). Changing A stretches the curve up and down, which has a dramatic effect on the gradient at P, where it crosses the 45° line, which in turn affects the iterative behaviour. In the four examples opposite, the differing slopes at P determine whether the result is an attractor or a repellor.

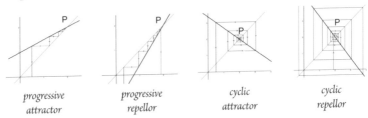

progressive
attractor

progressive
repellor

cyclic
attractor

cyclic
repellor

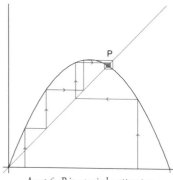

A = 2.6; P is a period 1 attractor.

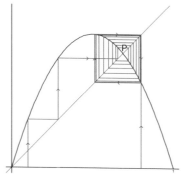

A = 3.2; P is a period 2 repellor.

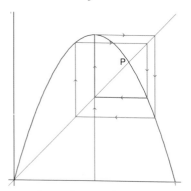

A = 3.5; P is a period 4 repellor.

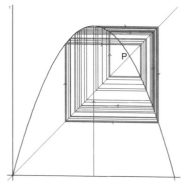

A = 3.6; P is a chaotic repellor.

Graphs of the logistic equation, $y = Ax(1-x)$, showing the effect of values of A on the slope at P (where the graph crosses the 45° line) and how this affects its iterative behaviour.

TOP LEFT: *When A = 2.6, the slope at P is less than 45° the result is a period 1 attractor.*
TOP RIGHT: *When A = 3.2 the slope at P is slightly greater than 45° and the result is a repellor which eventually finds a stable cycle of period 2 (the output bouncing between two values).*
LOWER LEFT: *When A = 3.5 the slope is even greater, resulting in a stable cycle of period 4.*
LOWER RIGHT: *As A increases further, the period doubles and doubles again, until the Feigenbaum point A = 3.56995... , after which chaos sets in.*

ISLANDS OF STABILITY
back to where you started

A glance at the Logistic Map (*page 25*) shows stable regions within the chaotic region, e.g. around $A = 3.83$. A theorem by Pierre Fatou states that if a stable cycle exists, it will always include the *critical point*, the value of x where the graph is a maximum, i.e. $x = 0.5$. If we define F_n as the nth iteration of the critical point, then we obtain:

$$F_1 = A/4 \; [= Ax\,(1-x) = A \times 0.5 \times (1-0.5)]$$
$$F_2 = A^2(4-A)/16$$
$$F_3 = A^3(4-A)(16-4A^2+A^3)/256$$
$$F_4 = A^4(4-A)(\textit{a polynomial of order 10})/65536 \ldots$$

These functions are picked out in bold in the diagrams below and opposite. They all behave sensibly when $A < 3$ but in the chaotic region they oscillate up and down more and more rapidly.

F_1 is an upper limit to the system, F_2 is a lower limit and subsequent F-lines define internal limits and density variations inside the chaotic region. But what causes the 'islands of stability'?

In the illustration below, the F_3 line crosses the line $x = 0.5$ at the point P. What this means is that at this unique value of A, the critical

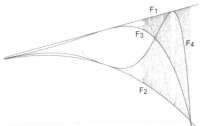

point $x = 0.5$ returns to 0.5 every 3 iterations (*see the panel opposite*), forming an island of stability.

Islands of stability of period n occur whenever the F_n line crosses the $x = 0.5$ line.

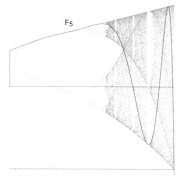

The F_5 line crosses the critical line in 3 places
so there are 3 islands of periodicity 5

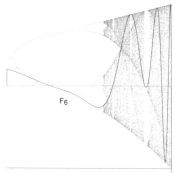

The F_6 line crosses the critical line in 7 places
but some of these have periodicity 2 and 3

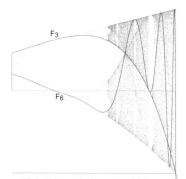

All the F lines which are divisible by 3 cross
the critical line in the period 3 island

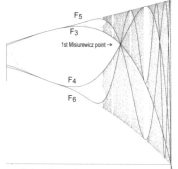

All the F lines above F_2 pass through the
same point, the first 'Misiurewicz point'.

THE PERIOD 3 ISLAND

The centre of the 3-island is at A = 3.832, where A is the solution to:
$$A^3(4 - A)(16 - 4A^2 + A^3) / 256 = 0.5.$$ Iterating the critical point (0.5) 3 times:

$$x_0 = x_c = 0.5 \qquad x_1 = 3.832 \times 0.5\,(1 - 0.5) = 0.958$$
$$x_2 = 3.832 \times 0.958\,(1 - 0.958) = 0.154$$
$$x_3 = 3.832 \times 0.154\,(1 - 0.154) = 0.5 \;...\; back\; where\; we\; started!$$

CHAOS IN THE REAL WORLD
butterflies and dripping taps

True chaos is quite hard to find in the real world. Contenders like radioactive decay, cloud shapes or the motions of lottery balls are merely random. For a system to be classed as chaotic two conditions must be met: FIRSTLY, it must behave predictably, so if you start it off twice with *exactly the same* initial conditions, the system must evolve in exactly the same way. SECONDLY, if you start it off with *slightly different* initial conditions, the system must quickly evolve differently. This phenomenon is known as 'extreme sensitivity to initial conditions' and it was first recognized by Edward Lorentz in the 1960s while developing a computerised model of the atmosphere. The flap of a butterfly's wing in Brazil, he said, might cause a tornado in Texas.

Modern meteorologists run their computer programs using up to 50 slightly different starting conditions. If the outputs of all the models broadly agree after 5 days they will give a confident forecast. However, if their models generate very different results, the atmosphere is in a chaotic state and they will confine themselves to tomorrow's weather.

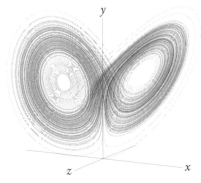

$$\begin{cases} \dot{x} = \sigma(y - x) \\ \dot{y} = x(\rho - z) - y \\ \dot{z} = xy - \beta z \end{cases}$$

$\sigma = 10$, $\beta = 8/3$ and $\rho = 28$.

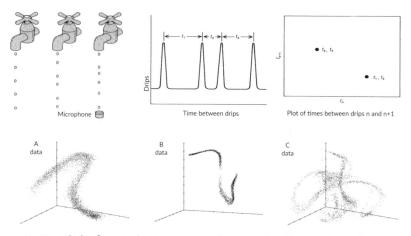

ABOVE: At higher flow rates dripping taps seem to become random. However, plotting the time intervals between drips n, n+1 and n+2 on an x, y, z chart reveals a swirling 3D chaotic attractor.

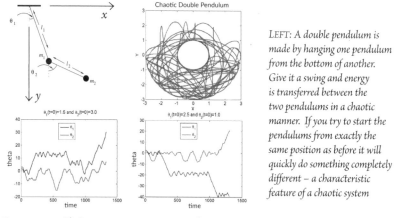

LEFT: A double pendulum is made by hanging one pendulum from the bottom of another. Give it a swing and energy is transferred between the two pendulums in a chaotic manner. If you try to start the pendulums from exactly the same position as before it will quickly do something completely different – a characteristic feature of a chaotic system

FACING PAGE: The Lorentz attractor is a system of equations in 3 dimensions which determine the path of a point in 3-dimensional space. For a while the point may go round and round one of the 'wings' of the attractor but from time to time, and for no apparent reason, the point switches to the other wing. The system is fully deterministic but exhibits extreme sensitivity to its initial conditions

Chaos in the Solar System

the three body problem

In 1687 Newton published his theory of gravitation which showed how a single planet can indefinitely orbit a star in an ellipse. However, in attempting to analyse the orbit of the Moon around the Earth, Newton was unable to find a simple formula which described the orbit of a satellite under the gravitational influence of more than one body.

The diagram (*below, by Julien Sprott*) shows the sort of orbit which can result from three interacting bodies: In this binary star system a planet orbits one star then it switches its allegiance to the second star before going back again. Eventually the planet will either collide with one or other of the two stars or it will be expelled from the system. Since tiny changes in the original position or velocity of the orbit can profoundly affect its future path, the orbit is said to be chaotic.

It turns out that, although the orbit of our Moon has been stable for millions of years, it has not remained the same over that time and there is no guarantee that the other planets, notably Jupiter and Saturn, might not at some time in the future gang up on the Moon or even the Earth and throw them out of the solar system. Nobody can be sure.

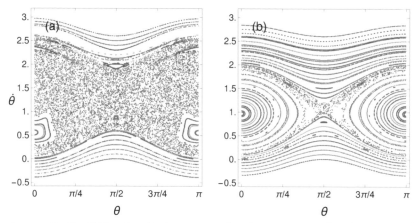

ABOVE: *168-mile wide Hyperion orbits Saturn every 21 days. Because it is potato-shaped, its moments of inertia along the three principal axes are very different so it has been unable to synchronise its rotational period with its orbital period (unlike our own Moon which always turns the same face towards us). As a result it tumbles about in its orbit chaotically. The graphs plot a simulation (Tarnopolski 2016) of the rate at which the moon rotates ($\dot{\theta}$) against the angle of rotation (θ) at the same instant on successive orbits for a number of different orbits – some quasi-periodic and others chaotic. Hyperion lies in the chaotic zone.*

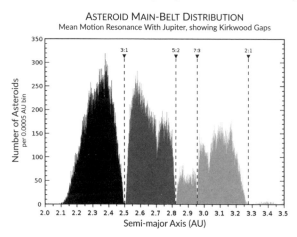

ASTEROID MAIN-BELT DISTRIBUTION
Mean Motion Resonance With Jupiter, showing Kirkwood Gaps

LEFT: *The distribution of asteroids in the asteroid belt is not uniform. At places where there is a simple resonance between the orbital period of the asteroid and that of Jupiter, prominent gaps appear. This is because these orbits are chaotic and subject to large changes in eccentricity which may put them on a collision course with other asteroids or even Mars.*

JULIA SETS

and complex numbers

An important class of IFS fractals are Julia sets, which are produced by examing the behaviour of the *complex plane* under the transformation: $z \rightarrow \sqrt{(z - c)}$, where z and c are *complex numbers*, taking the form $z = x + iy$, and $c = a + ib$, where a and b are constants and $i = \sqrt{-1}$.

The square roots of negative numbers (i, $2i$, $-5i$ etc) were discovered by Gerolami Cardano in the 16th century and the number plane is today seen as complex, meaning it consists of a horizontal axis of *real* numbers and a vertical axis of *imaginary* numbers. When you square root a complex number, as with real numbers, there are always two complex answers, and in the Julia transformation (*see below*) we move from P to Q by subtracting c (= $a + ib$), and then square root Q to give the two solutions R1 and R2 (*see appendix page 58*).

Another way to handle a complex number is to use *polar notation*

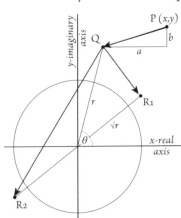

(*left*), i.e. use its distance r from the origin (its *modulus*) and the angle θ this makes with the x–axis (its *argument*). So, $Q = (x-a) + i(y-b)$ can also be written as $\{r, \theta\}$. To find the square root of a number in polar notation, you simply square root the modulus and halve the argument:

$R1 = \{\sqrt{r}, \theta/2\}$
$R2 = \{-\sqrt{r}, \theta/2\}$.

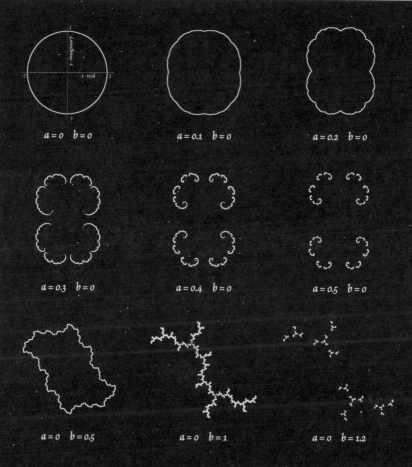

ABOVE: Julia sets. If a and b (the real and imaginary parts of the complex constant c) are both zero, the fractal is a circle, but increasing a or b distorts the circle until, at some point, the fractal breaks up into fragmentary pieces. Like other strange attractors, it doesn't matter where you start, the square root function homes in on its attractor in just the same way that repeatedly taking the square root of any positive (real) number always homes in on the number 1. Some Julia sets are connected, resulting in an inside and an outside, while others are disconnected and have no inside.

THE ESCAPE ALGORITHM

how long does it take to get out?

A Julia set is an attractor: any point in the plane homes in on the set. Now consider what happens if we apply the reverse operation: $z \rightarrow z^2 + c$; that is, we start with a complex number and square it (or, in polar notation, square the distance and double the angle) and add the constant. In most cases this process will rapidly carry z further and further away from the set; but if the Julia set is connected, then points which start inside the set will remain forever trapped there.

To generate the images on these pages, every point on the plane is iterated repeatedly until either the point passes some sufficiently large predefined distance (bailout) from the origin, or we reach, say, 1000 iterations. If the latter, then we assume this point is trapped inside the set and colour it black, otherwise we colour the point (or pixel) in a shade of grey according to the number of iterations needed to escape.

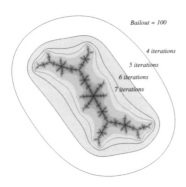

Bailout = 100

4 iterations

5 iterations

6 iterations

7 iterations

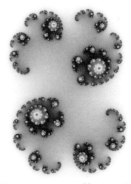

Julia map with a = -0.101 and b = 0.956. This map is connected but has no interior.

Julia map: a = 0.34 and b = 0.04. Not connected. All points escape to infinity.

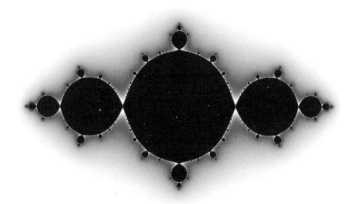

ABOVE: *Julia map with a = -0.9 and b = 0. This map is connected, so all points which start inside the boundary remain trapped there and are coloured black. Note that all Julia maps have 180° rotational symmetry (a result of the two square roots R1 and R2 being diametrically opposed).* BELOW: *A collage of Julia sets close to the origin, plotted by their values of C. An enigmatic shape begins to appear.*

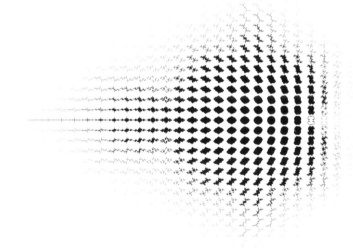

FROM JULIAS TO MANDELBROT

the most complex object in mathematics

In 1978, Robert Brooks and Peter Matelski at the State University of New York at Stony Brook used the university computer to plot the centre points of all the Julia sets in the plane. Early computers were not equipped with sophisticated displays so it was a common pastime to print out images using asterisks. Imagine their surprise when this diagram gradually emerged from the printer (*opposite top*)!

But how do we plot the famous Mandelbrot Map (*lower, opposite*), often dubbed the most complex object in the mathematical universe? To plot a Julia map we iterate $z \rightarrow z^2 + c$ with a fixed c and z starting at the coordinate being coloured, p. To produce the Mandelbrot map we instead iterate $z \rightarrow z^2 + p$ with z starting from $z = (0, 0)$ which is the *critical point* for this function. Again, we colour the pixel according to the number of iterations needed to reach the bailout value (*page 36*).

For such complexity, the code is ridiculously simple (*the differences between the Julia and Mandelbrot algorithms are shown in the pseudocode below; for more details on how they can be implemented see the appendix, page 58*).

```
Function Julia (C)                          Function Mandelbrot
                    For y = 0 to Screenheight
                    For x = 0 to Screenwidth
z = complex(x, y)              C = complex(x, y) : z = (0, 0)
                         count = 0
                          Repeat
                        z = z² + C
                     count = count + 1
         Until either Modulus(z) > bailout or count > 1000
                   Plot(x, y, colour(count))
                      Next x : Next y
                          Return
```

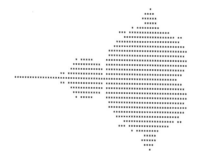

LEFT: *The very first image of the Mandelbrot map produced by Brooks and Matelski in 1978.*

BELOW: *A modern gradient plot of the Mandelbrot Map—the number of iterations required to exceed the limit denotes the 'height' of a pixel.*

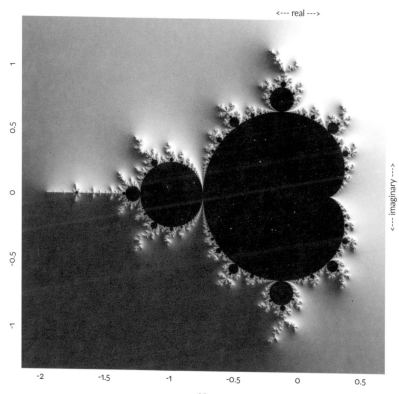

<--- real --->

<--- imaginary --->

THE MANDELBROT MAP
where mathematics becomes pure art

In 1982 Benoit B. Mandelbrot published *The Fractal Geometry of Nature* and soon everyone with a personal computer (including me) was writing simple programs to generate pictures of Julia sets, ferns and clouds. (What the 'B' in Mandelbrot's name stands for is unknown, but some wag has suggested that it stands for 'Benoit B. Mandelbrot'.)

Although these objects had their interest, it is the Mandelbrot map itself which enthralled us most of all because, unlike ordinary fractals which are generally self-similar, the Mandelbrot map is different. As you zoom in, new structures and patterns appear and whenever you come across a structure which looks familiar—a minibrot for example—you will find that it is subtly different and incorporates new features not found in the upper levels.

The Mandelbrot map is not just the Mandelbrot set. The latter refers to the set of all points for which the corresponding Julia set is connected and is usually coloured black. It is the edge of this set and the points just outside it which are of greatest interest, not the set itself.

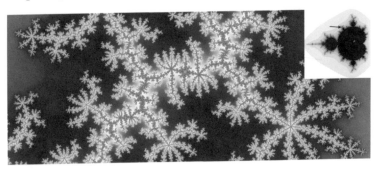

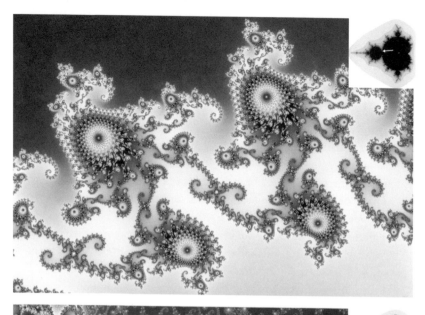

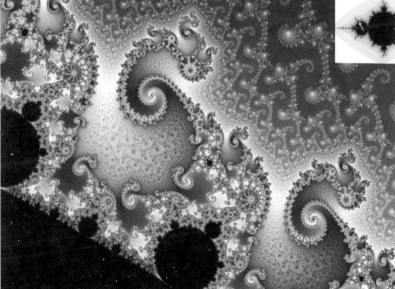

ZOOMING IN
deeper and deeper

Magnify any region just outside the Mandelbrot set and you will almost certainly come across a little miniature version of the whole, a *minibrot*. Minibrots have all the wealth of detail that the primary mandelbrot possesses and more—each one being embedded, as it were, in detail that echoes its immediate surroundings. The images on the opposite page are all of exactly the same location but at different magnifications. First we zoom into what looks like a thorn; then spirals appear which resolve themselves into a double then fourfold and then eightfold structure, the centre of which turns out to be a minibrot. The final magnification of this sequence is about 2500 billion. At this scale the Mandelbrot map would be the size of the solar system!

The sheer depth of Mandelbrot images can be quickly conveyed by colouring alternate levels black. Below we see two images of the same location with different colouring. The dull areas between the spiral arms are transformed into huge roots which spiral down into unfathomable depths, splitting into ever smaller rootlets.

Search the internet for 'Mandelbrot Zoom' videos to see the extraordinary beauty and complexity of the Mandelbrot map.

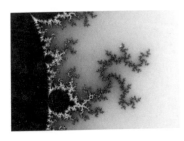 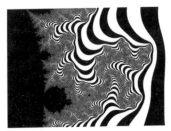

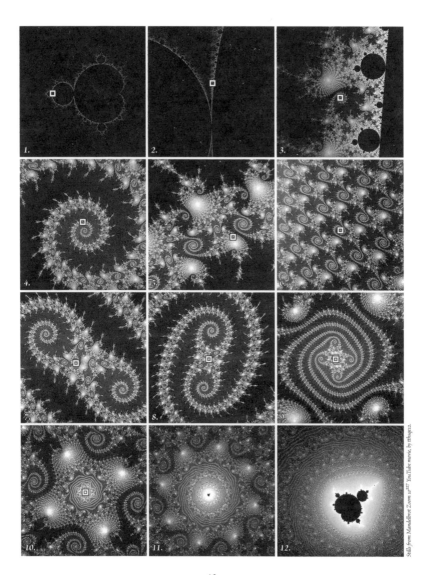

Stills from Mandelbrot Zoom 10²²⁷ YouTube movie, by tEdognt12.

43

LABELLING THE LOBES
the keys to the set

To begin our exploration of Mandelbrot map, let's label the main body of the map (or 'cardioid') Lobe 1, and the lobes coming off it 2, 3, 4, 5, 6 etc in order of size, moving clockwise and starting with Lobe 2 on the left (*opposite top*). These are the principal lobes of Lobe 1 and should strictly be labelled 1:2, 1:3, 1:4 etc, where the colon means 'attached to', but since every lobe name starts with "1:" we can omit this prefix. We will also leave the lobes below the x-axis unlabelled for now as they reflect those above. The principal lobes attached to Lobe 2, again starting with the largest, are labelled 2:2, 2:3, 2:4 etc.

Between Lobes 3 and 4 is a prominent lobe (*opposite*) which we shall label 4›3, where the "›" means "moving towards". But why is this lobe called 4›3 and not 3›4? Well, a secondary lobe like this one is reached by means of alternate clockwise and anti-clockwise sequences as shown in the diagram below. Lobe 4 is the start of a secondary anticlockwise sequence of lobes labelled: 4; 4›3; 4›3›3; 4›3›3›3 etc. The tertiary clockwise sequence starting at Lobe 4›3 goes 4›3; (4›3)›4; (4›3)›4›4; (4›3) ›4›4›4 etc. (Note the brackets, and that labels can be shortened, e.g. 4›3 ›3›3 to 4›3³). Using this scheme, every lobe has a unique label.

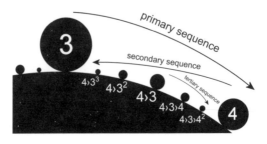

44

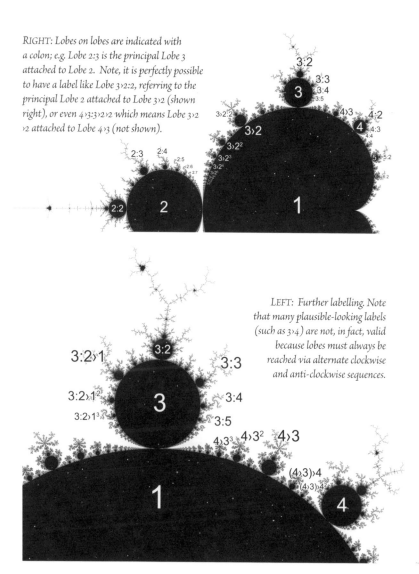

RIGHT: Lobes on lobes are indicated with a colon; e.g. Lobe 2:3 is the principal Lobe 3 attached to Lobe 2. Note, it is perfectly possible to have a label like Lobe 3›2:2, referring to the principal Lobe 2 attached to Lobe 3›2 (shown right), or even 4›3:3›2›2 which means Lobe 3›2 ›2 attached to Lobe 4›3 (not shown).

LEFT: Further labelling. Note that many plausible-looking labels (such as 3›4) are not, in fact, valid because lobes must always be reached via alternate clockwise and anti-clockwise sequences.

45

AXONS AND SYNAPSES

the secret code of the map

Around the Mandelbrot Map may be found *neurons*, structures which sprout from the end of lobes. These have an *axon*, which connects the lobe to a *synapse*, a branching point from which *dendrites* emerge. Between any two synapses there is always a minibrot and vice versa. The number of branches in a synapse is called its *order*.

The order of a synapse relates to the label of the lobe to which it is attached. So, Lobe 3:4 (*below left*) has synapses of both order 3 and 4, with the *principle synapse* (closest to the lobe) being order 4. Lobe 4:3 (*below right*) works in a similar way.

Now a glance at the illustration on the previous page will reveal a remarkable fact about the principal lobes of Lobe 1: the order of its principal synapse is equal to the the label of the lobe to which it is attached! But that is not all. You will also discover that the order of the synapse attached to Lobe 4›3 is 7 and that the order of the synapse on Lobe (4›3)›4›4 is 15. In other words, to predict the order of any synapse you just add up all the numbers after the ':' in the lobe label!

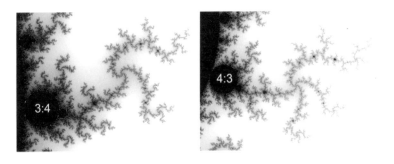

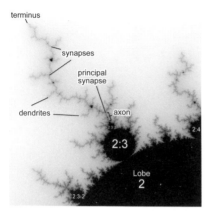

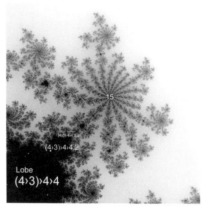

ABOVE LEFT: *Labelling a 'Neuron'. The Principal Synapse of Lobe 2:3 has order 3 because it has 1 axon which splits into 2 dendrites (1 + 2 = 3). The neuron attached to Lobe 2:3 is really attached to 2:3:2, in fact to an infinite number of smaller lobes, each with label 2. The full label of its point of contact should, in fact, be 1:2:3:2:2:2:2 ... This is why the axon is in fact an infinite series of order 2 synapses.*

ABOVE RIGHT: *This neuron on Lobe (4›3)›4›4 has order 15, because 4+3+4+4 = 15.*

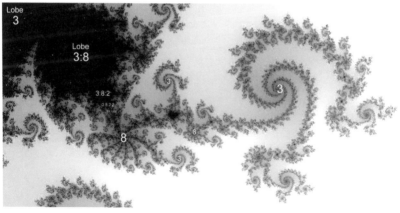

ABOVE: *The neuron above has principle synapse order 8 and the spirals are of order 3, so the parent lobe is 3:8. All the lobes along the edge of lobe 3 have similar order 3 synapses, but as we move round the lobe, the synapse becomes more and more spiral. Further complexities reward the keen student.*

ITERATIVE ORBITS
periodicity and step size

The colour (or 'height') of any point in the Mandelbrot map is calculated by seeing what happens to z under repeated squaring and adding of a constant c (*see pages 38 & 58*). If the constant c lies outside the set then z scampers off to infinity more or less quickly, but if c lies inside the cardioid or any of the lobes then it travels in a periodic cycle.

A pattern may be observed. If the constant c is inside Lobe 1, then z homes in on a single value. If it is inside Lobe 2, then z will eventually oscillate between 2 values, displaying a *periodicity* of 2. If it is inside Lobe 5, then z oscillates between 5 values (*opposite top left*). It is no accident that the periodicity of the lobe is equal to the order of its principal synapse (*see previous page*). Note that we can also find a periodicity of 5 by starting in Lobe 3.2, although the *step size* will differ (*opposite top right*). There are two principles here:

Periodicity of a lobe = order of principal synapse = sum of the lobe label
Step size of a lobe = number of numbers in the lobe label

Note that with secondary lobes like 3:2 the periodicity is the *product* of the numbers, i.e. 6 (*lower, opposite*). In the same way, for constants inside the principal axon 2:2 (*below*), z enters an orbit with periodicity 4, while the periodicity inside lobe 2:2:2 is 8, etc.

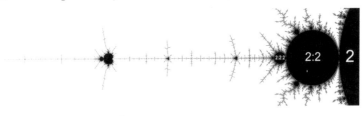

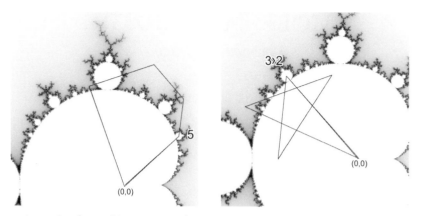

ABOVE: *Periodicity and Step Size.* LEFT: *If **c** is inside Lobe 5 then a pentagon is produced.* RIGHT: *If **c** is inside Lobe 3›2 then **z** traces a pentagram (as 3+2=5). Both these lobes have the same periodicity, of 5 repeated points, but have different Step Sizes: Lobe 5 has a step size of 1, as z steps round the points one at at time, while Lobe 3›2 has a step size of 2, and z steps round the points 2 at a time.*

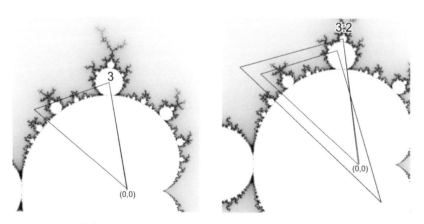

ABOVE: *Calculating the periodicity of secondary lobes.* LEFT: *When **c** is inside Lobe 3, **z** will trace a triangle.* RIGHT: *If **c** is inside Lobe 3:2 then the primary order of 3 is retained, but the triangle splits into two, doubling the periodicity to 6 (= 3 × 2).*

MORE FAREY MAGIC
above and below

A unifying pattern hides in the Mandelbrot Map. For any lobe attached to the main cardioid, create a *Rotation Number*, or *Farey fraction* equal to the step size over the periodicity (*see opposite*). The Farey fraction of any lobe is the Farey sum (*see page 14*) of the Farey fraction of the previous lobe and that of the lobe towards which the sequence is heading (*see zigzag diagram, page 44*). Knowing the Farey fraction you can easily say approximately where on the main cardioid the lobe lies (but not exactly because the cardioid is a distorted circle).

Remarkably, the Farey fractions of all the lobes attached to the cardioid form what is called a Stern-Brocot sequence (*see below*), with each fraction equal to the Farey sum of the two fractions connected to its left. We have met this before as the sequence of Ford circles (*see page 14*). The Stern-Brocot tree contains every rational fraction in its lowest terms. It follows that for any two mutually prime numbers s and p ($s < p$) there exists a lobe with step size s and periodicity p.

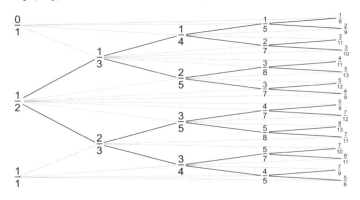

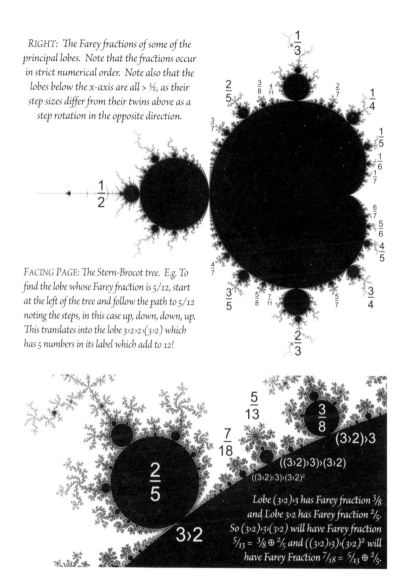

RIGHT: *The Farey fractions of some of the principal lobes. Note that the fractions occur in strict numerical order. Note also that the lobes below the x-axis are all > ½, as their step sizes differ from their twins above as a step rotation in the opposite direction.*

FACING PAGE: *The Stern-Brocot tree. E.g. To find the lobe whose Farey fraction is 5/12, start at the left of the tree and follow the path to 5/12 noting the steps, in this case up, down, down, up. This translates into the lobe 3›2›2›(3›2) which has 5 numbers in its label which add to 12!*

$\frac{1}{3}$

$\frac{2}{5}$ $\frac{3}{8}$ $\frac{4}{11}$ $\frac{2}{7}$ $\frac{1}{4}$

$\frac{3}{7}$ $\frac{1}{5}$
$\frac{1}{6}$
$\frac{1}{7}$

$\frac{1}{2}$ $\frac{6}{7}$
$\frac{5}{6}$
$\frac{4}{5}$

$\frac{4}{7}$

$\frac{3}{5}$ $\frac{5}{8}$ $\frac{7}{11}$ $\frac{5}{7}$ $\frac{3}{4}$

$\frac{2}{3}$

$\frac{5}{13}$ $\frac{3}{8}$

$\frac{7}{18}$ $(3›2)›3$

$((3›2)›3)›(3›2)$

$\frac{2}{5}$ $((3›2)›3)›(3›2)^2$

$3›2$

Lobe (3›2)›3 has Farey fraction $\frac{3}{8}$
and Lobe 3›2 has Farey fraction $\frac{2}{5}$.
So (3›2)›3›(3›2) will have Farey fraction
$\frac{5}{13} = \frac{3}{8} \oplus \frac{2}{5}$ and $((3›2)›3)›(3›2)^2$ will
have Farey Fraction $\frac{7}{18} = \frac{5}{13} \oplus \frac{2}{5}$.

THE ANTENNA

minibrots in a line

The neuron attached to Lobe 2 is special because it is a straight line. Like all neurons (*see page 38*), this is not just attached to Lobe 2—it is attached to lobe 2:2, and lobe 2:2:2 and lobe 2:2:2:2, etc. In fact it is attached to an infinite number of lobes, all of order 2. This means that the neuron has an infinite number of order 2 synapses along it, and because they are of order 2 they are all absolutely straight and therefore invisible. Also, between every pair of synapses you will find a minibrot, so there are an infinite number of these as well.

The large minibrot is worth closer study: firstly it seems to have sprouted a lot of 'hair' (and all the elephants and seahorses which it contains have 'hair' too). The smaller minibrots along the axis are surrounded by an aura of flames and the minibrots close to the cusp of the largest minibrot on the axis are surrounded by cauliflower explosions which themselves contain some exquisite jewels (*one of which is illustrated below*). If you have never used a computer program to explore the Mandelbrot map, now is the time!

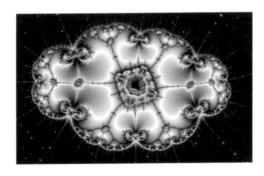

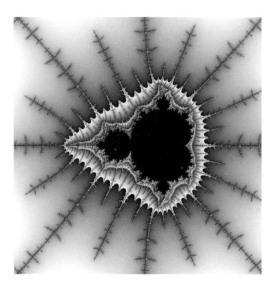

LEFT: As we zoom in to minibrots along the antenna, more and more complexity appears. This minibrot has sprouted 16 long spikes, another 16 shorter ones, and many smaller ones in between.

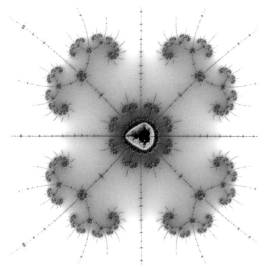

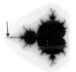

LEFT: At deeper zooms still, the minibrot spikes begin to grow long thin branches of their own, with even more delicate and elaborate structures appearing around branch points.

FACING PAGE: A beautiful jewel, close to one of the largest minibrots on the axis.

ORDER AND CHAOS

united in the Mandelbrot Map

The neuron attached to Lobe 2 (the 'antenna') is special for another reason. Since the y component is zero, the equation which iterates (x, y) simplifies to $x \rightarrow x^2 + p$, where p is the x-coordinate of the pixel.

Try a few values of p with a calculator. If $p = 1$ then x jumps from 0 to 1, to 2, then 5, and 26, etc. Nearly all positive values of p skip off to infinity, as do all values less than -2. But in between, with $p = -1$, 0 goes to -1, then back to 0, etc, oscillating between two values. Try $p = -1.311$. After four iterations, you will be nearly back to 0 again.

The graph (*opposite*) shows the behaviour of x (vertical axis) in relation to the Mandelbrot map. Inside Lobe 1, x homes in on a single value. Moving through Lobes 2, 2:2, 2:2:2... x bifurcates into 2, then 4 then 8, 16, 32, 64 branches, etc. – the periodicities of the respective lobes. But when we reach $p = -1.4011551890...$ (the *Feigenbaum point*, where the neuron actually starts) we enter the region of patternless *chaos*.

Bifurcations in this and other chaotic quadratic systems tend towards a limiting ratio with respect to their neighbours—the *Feigenbaum constant*, 4.669201609. The sequence below shows how a zoom of this magnitude applied to lobes 2, 2:2 and 2:2:2 preserves their relative size.

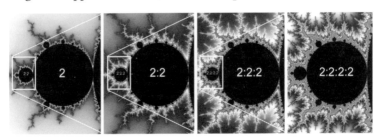

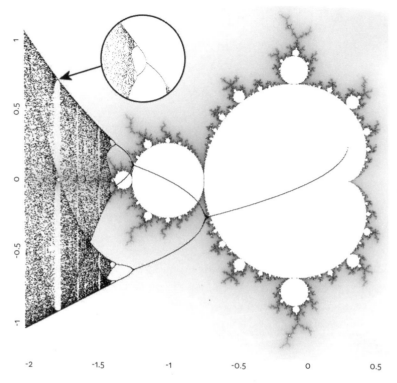

ABOVE: *The overlaid graph shows the behaviour of x (plotted vertically) under $x \rightarrow x^2 + p$ for all values of p from -2 to 0.25 (ignoring the first 100 or so iterations). The magnified insert shows the fractal nature of the map. Note how every 'island of stability' ends with a bifurcation sequence. Within the chaotic region, when $p < -1.4$, the 'islands of stability' correspond exactly with minibrots along the axon. E.g. at $p = -1.757$, x has periodicity 3, and around $p = -1.674$, x has periodicity 7. In fact you can find minibrots with every possible period along the antenna, but between these are unique values of p for which x is chaotic and never repeats—the order 2 synapses we saw on page 52.*

It is no accident that the general shape of this graph is similar to that of the Logistic Equation (see page 25). This is because both functions are quadratic. All functions with a maximum or minimum value generate the same sequence of bifurcations, even trig functions like sin and cos.

Newton Raphson Fractals

getting to the root of it

The Escape Algorithm is not the only way of generating interesting fractals. Another method is based on the Newton Raphson method of finding solutions to an algebraic equation. This involves making a guess at a solution and then repeatedly applying the algorithm so that the guess gets better and better.

For example, if you want to solve the equation $x^2 - 4 = 0$, the equation you need is $(x^2 + 4)/2x$ (*see opposite*). Suppose you guess the answer is somewhere near 5. Plug 5 into the formula and you get 2.9; plug this into the formula and you get 2.1; the more times you do this the closer you will get to the correct answer which is, of course 2. Except that the equation has another solution, namely −2. To get to this answer you might have to start with −5. You might think that all positive guesses would migrate towards 2 and all negative ones to −2 (and in this case you would be right), but this is not always the case. Fascinatingly, the boundary between such 'basins of attraction' can be fractal.

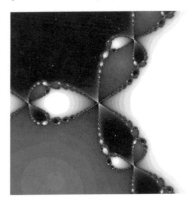

The complex equation $z^3 - 1 = 0$ has three roots, +1, $-1/2 + \sqrt{3}i$ and $-1/2 - \sqrt{3}i$. If we colour all the starting points which end at +1 in white, those that end at $-1/2 + \sqrt{3}i$ in black and those that end at $-1/2 - \sqrt{3}i$ in grey we get a threefold fractal image (*shown left*).

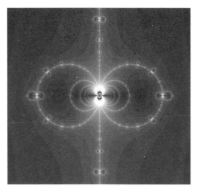

$z^3 + 1.5z^2 = 1$ (detail)

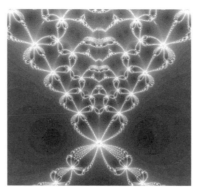

$z^{3.7} = 1$

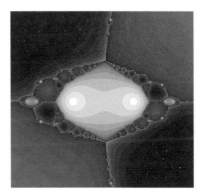

$sin(z) = 0$

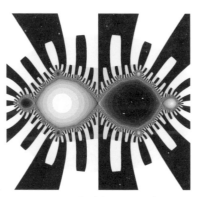

$1/z^2 = 1$ (with binary escape)

The Newton-Raphson formula.

$$x' = x - \frac{f(x)}{f'(x)}$$

$f(x)$ is the function whose solution we seek and $f'(x)$ is the derivative of the function. So if $f(x) = x^2 - 4$, then $f'(x) = 2x$ and the formula we need to use is
$x' = x - (x^2 - 4)/2x = (x^2 + 4)/2x$

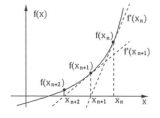

Appendix - Fractal Mathematics

The Hausdorff Dimension

If it takes P copies to make a fractal Q times larger then the Hausdorff dimension is n where $Q^n = P$.

To solve this equation for n we take the logarithm of both sides giving us $n \log Q = \log P$, or $n = \log P / \log Q$.

For example, to calculate the Hausdorff dimension of the Koch curve, P = 4 and Q = 3, so on a scientific calculator simply press [log] [4] [÷] [log] [3] [=], or use natural logarithms [ln], it makes no difference!

Complex Numbers

Any point in the plane (x, y) can be represented as a complex number in two ways: either as $z = (x + iy)$ or $z = re^{i\theta}$ where i is the square root of -1, r is the modulus of the number (i.e. the distance of the point from the origin) and θ is the argument (i.e. the angle at the origin).

Using the ordinary rules of algebra z^2 may be written as either $(x^2 - y^2 + 2xyi)$ or $r^2e^{2i\theta}$. Using the latter form it is easy to see that squaring a complex number is achieved by squaring the modulus (r) and doubling the argument (θ).

To take the square root of a complex number we take the square root of the modulus (r) and halve the argument (θ).

The Mandelbrot Algorithm

To colour the pixel at $p = a + ib$ on the Mandelbrot map, we repeatedly square the point z (starting with $z = 0$) and add p:

$$z \to z^2 + p$$

To square a complex number we need to separate the real and imaginary parts, and the transformation which we need looks like this:

$$x \to x^2 - y^2 + a$$
$$y \to 2xy + b$$

It is wonderful to think that all the incredible detail of the Mandelbrot map is contained in two simple equations!

Further Reading:

The best introduction to the development of fractals and chaos theory is still James Gleick's *Chaos*, Penguin, 1988.

For a more detailed mathematical treatment, try Barnsley et al., *The Science of Fractal Images*, Springer-Verlag, 1988.

For further elaboration on the material in this book, please consult *The Mandelbrot Map*, and *Chaos and the Logistic Equation*, both available for download from the author's website: *www.jolinton.co.uk*.